ONE - TRACK
MIND

ONE - TRACK MIND

A revealing insight into the obsessed minds of men
Tony Davidson

Photography © Tony Davidson

First published in Great Britain in 2008 by
Virgin Books
Random House, 20 Vauxhall Bridge Road,
London SW1V 2SA

www.virginbooks.com
www.rbooks.co.uk

Addresses for companies within The Random House Group Limited can be found at:
www.randomhouse.co.uk/offices.htm

The Random House Group Limited Reg. No. 954009

A CIP catalogue record for this book
is available from the British Library

UK ISBN: 9780753515518 USA ISBN: 9780753516904

The Random House Group Limited supports The Forest Stewardship Council [FSC], the
leading international forest certification organisation. All our titles that are printed on
Greenpeace approved FSC certified paper carry the FSC logo.
Our paper procurement policy can be found at www.rbooks.co.uk/environment

Designed by www.carterwongdesign.com

Printed and bound by Firmengruppe APPL, aprinta druck, Wemding, Germany

To Judy and in memory of Michael.

With thanks and love to Ran.

I'd hardly call myself an author. I didn't set out to write this book. It's been an organic process that has led me here. I'm an ideas guy. As part of my creative process I collect lots of things for no reason. Ten years ago I started collecting things that look like breasts. The collection grew and friends added their own pictures.

The media would have us believe that there is a perfect size.

I thought it would be interesting to interview men to see what they really thought about this part of the female form. I started collecting interviews. Then I put snippets from these interviews against the most appropriate images I'd collected. I like it when you put two things together that were not intended for each other.

The result I hope is a book that will make people smile and hopefully understand that not all men are the same and most are just happy to be around such beautiful objects, after all it's not until later in life that we grow our own.

My mother was diagnosed with breast cancer in 2006. My father died later that same year, following a long battle against prostate cancer. For this reason I will be donating proceeds from this book to breast and prostate cancer research.

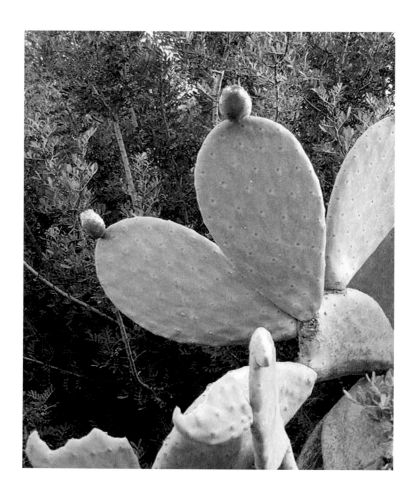

01

"One of the most appealing things is the variety of shapes, colours and sizes they come in."

Rory

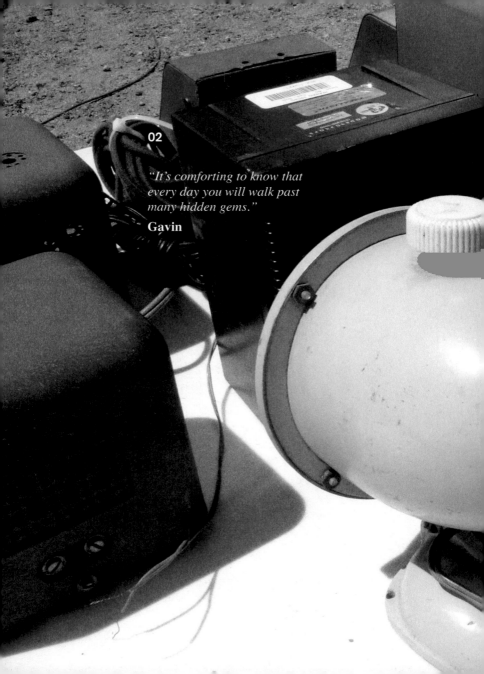

02

"It's comforting to know that every day you will walk past many hidden gems."

Gavin

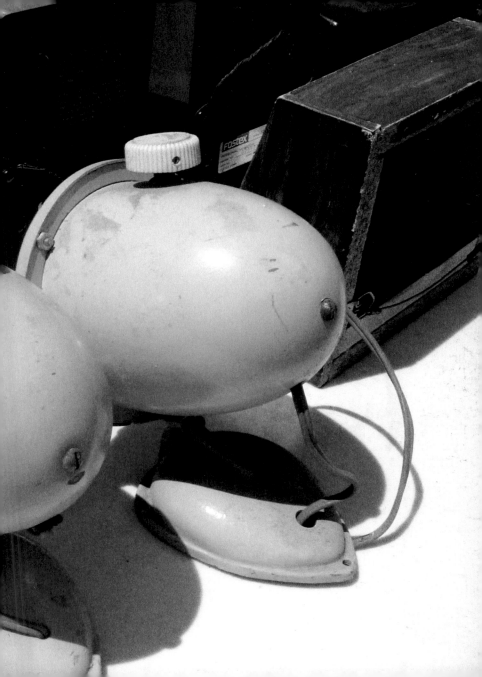

03

"It's hardly surprising that women are not attracted to men in the same way. The penis and genitals are not nearly as aesthetically pleasing."

Malcolm

04

"Pierced nipples are not my idea of fun. It's like adding fluffy dice to an Aston Martin."

Brian

05

"I like them best when they are covered in oil."
Sergio

06

*"It depends where you are coming
from. In Africa we like big ones
because they are good to cuddle,
especially when you're in bed with
the lady. People in England don't
die for the big ones, they like the
smaller versions. But we like them
big. We die for it. We love it."*

Victor

07

"If you can get something fixed why wouldn't you? Having had three children my wife didn't want to end up with them around her waist like those old women I used to see serving tea in church on Sunday."

Jonathan

08

"I read somewhere that men like them because they echo the buttocks, which are primary sexual features."

Tom

09

"It may sound childish, but seeing a fine cleavage can brighten your whole day and make you forget all your troubles for a moment."

Alun

10

"It's like a mental illness. A man can be having a serious, grown-up conversation with a woman he finds totally unattractive, but if there is a centimetre of cleavage on display, it's beyond the self-control of a Buddhist monk to let it go un-peeked at."

Pete

11

"I was in Miami last week and it was hard not to walk into walls and lampposts with all the silicone bouncing around."

Stan

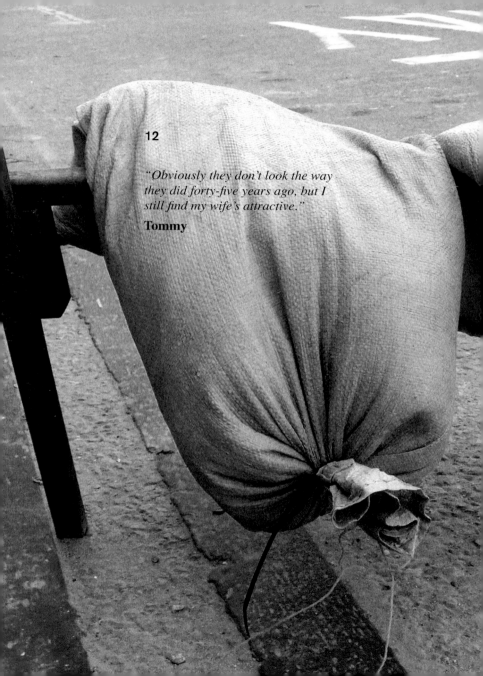

12

"Obviously they don't look the way they did forty-five years ago, but I still find my wife's attractive."

Tommy

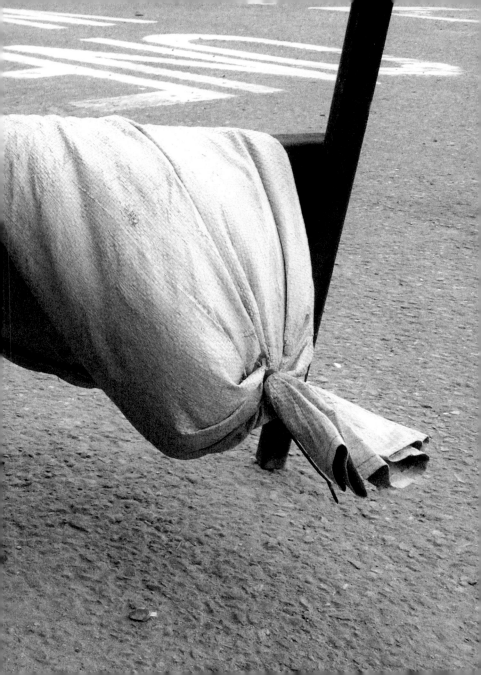

13

"As they start work on maternal duty their usefulness in the attraction stakes diminishes and that's as it should be. Guys sometimes find it hard to cope with this."

Dick

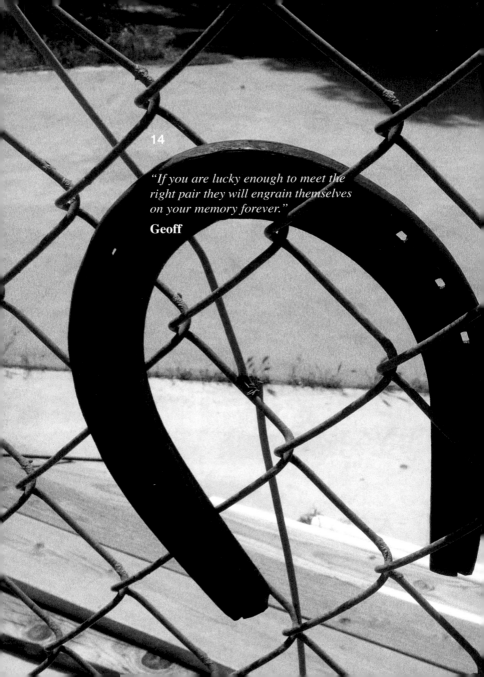

"If you are lucky enough to meet the right pair they will engrain themselves on your memory forever."

Geoff

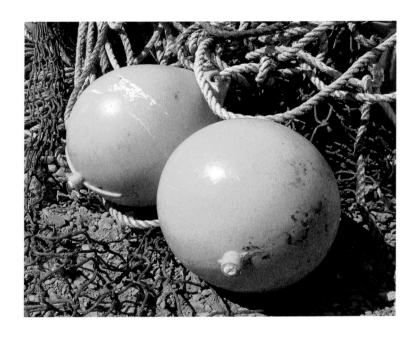

15

"Let's just say it's true what they say. . .
everything is bigger in America."
Alex

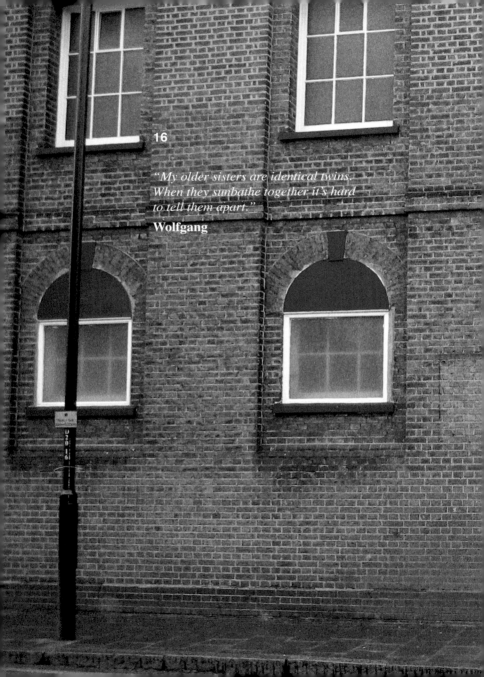

16

*"My older sisters are identical twins.
When they sunbathe together it's hard
to tell them apart."*

Wolfgang

17

"It's often difficult not to stare,
especially at the special varieties."

John

18

"After fifty men seem to switch their attention to bird feeders and barbecue sets. Perhaps that explains why there are so many garden centres."

Stuart

19

*"I think the best letters of the alphabet
are the ones with the biggest curves. I
don't know why but I look at these and
my brain releases endorphins."*

Simon

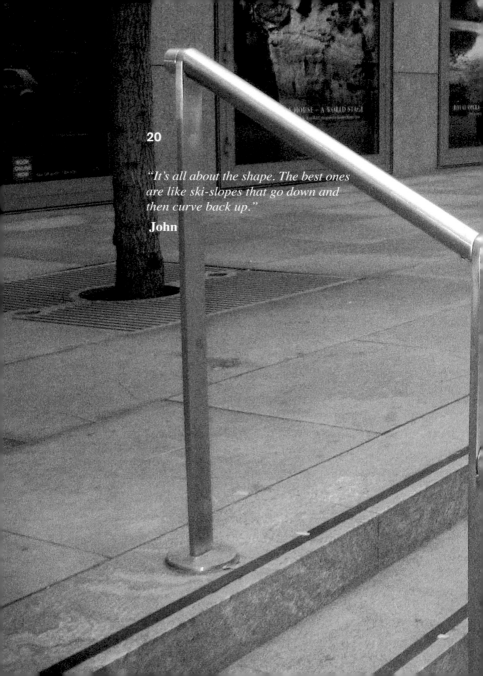

20

"It's all about the shape. The best ones are like ski-slopes that go down and then curve back up."

John

21

"My wife knows that I'm attracted to large ones. Every time she sees someone with them on TV she says 'Darling, you've got a girlfriend on TV'. She jokes about it all the time."

Roberto

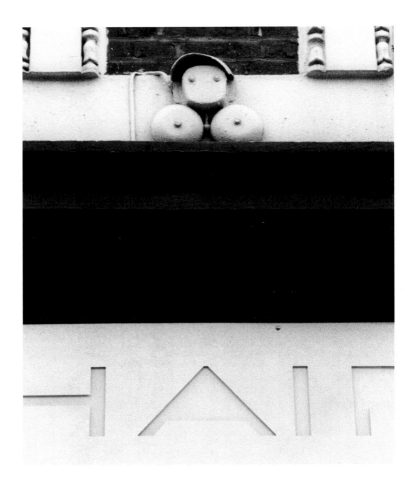

22

*"I am a believer that the sexiest thing
a woman can wear is confidence,
whatever this modern world can do
to supply it, then I am happy with
the outcome, but girls, just don't
do it because you think WE like
them a certain size. We are not that
advanced."*

Simon

23

"It's like football. We can happily sit down with other fans and talk about them for hours."

Benjamin

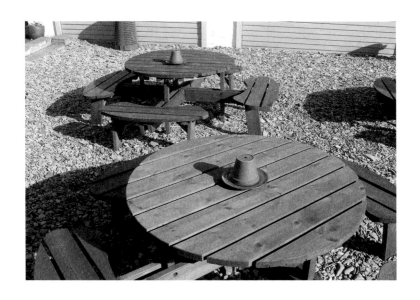

"I don't like tan lines. It makes them look alien. More power to topless sunbathing I say."

Colm

25

"I wish I had a pair. They can get you free drinks."

Joel

26

"I'm eighty-one. Trust me, the desire to look never fades, it just gets less lustful and more appreciative."

Ron

*"Bazongas, bazookas, boobs,
boobies, bristols, cans, charlies,
chaps, cheese balls, cupcakes, cottage
loaves, duelling banjos, flapjacks,
fog lights, fried eggs, fun bags, hand
warmers, honkers, hooters, jubblies,
jugs, knockers, mammaries, melons,
mountains, norks, orbs, over the
shoulder boulders, pillows, sweater
meat, ta-tas, tits, treacle tits, twangers,
warheads, winnebagos, woofers.
Clearly we are obsessed."*

Jim

28

*"I can't understand why women get
so offended when you notice what they
have so obviously put on display."*

Errol

29

"We are clearly not in control. Women have us in their grip."

Chris

find it at the airport

30

"Lots of great design uses curves to their advantage to make them feel warm and enveloping."

Matt

ESC
08

No
trolleys

31

"They look great in the packaging.
Women know this. But when you open
the box it's often a let down. They
should come with a guarantee. If they
don't deliver you should be able to
take them back and get a refund."

Andrew

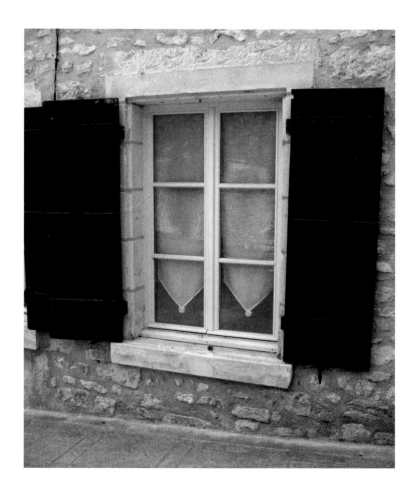

32

*"Temptation is a terrible thing.
We very rarely stop and think
about the consequences."*

Kai

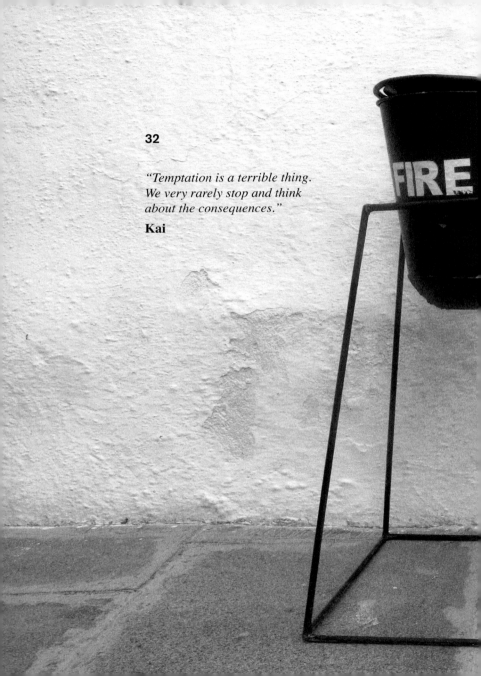

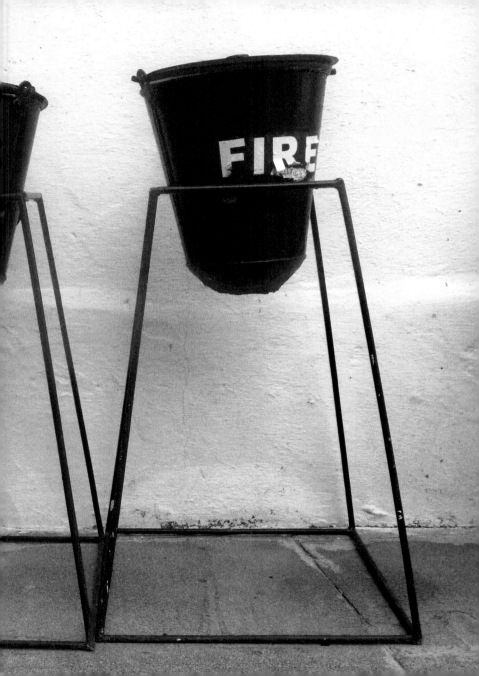

33

"There is a certain gap, about the width of two fingers. The size doesn't matter, it's the space in between that really counts."

Keith

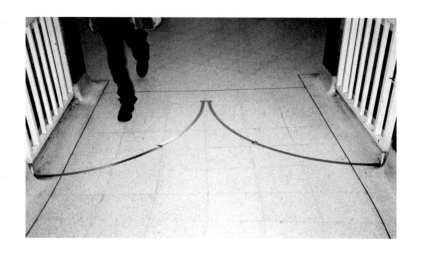

34

"Implants are the equivalent of listening to Mozart with ear-plugs in, or looking at a Picasso in a darkened room."

Simon

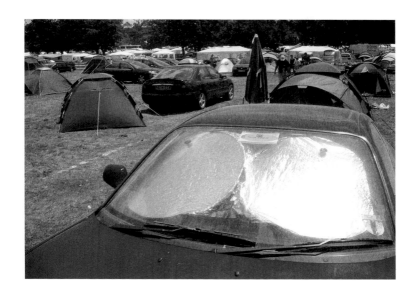

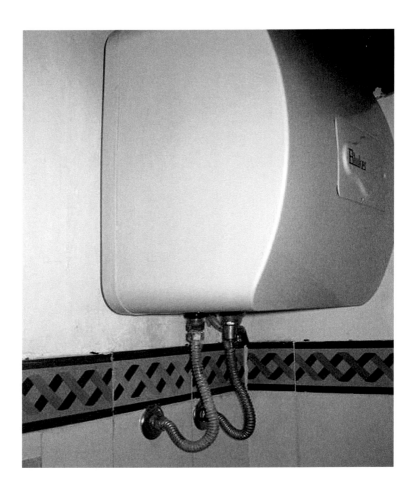

35

"It's all about proportion. Big are fantastic if the body can take them. Small are just as fantastic if the body demands that."

Paul

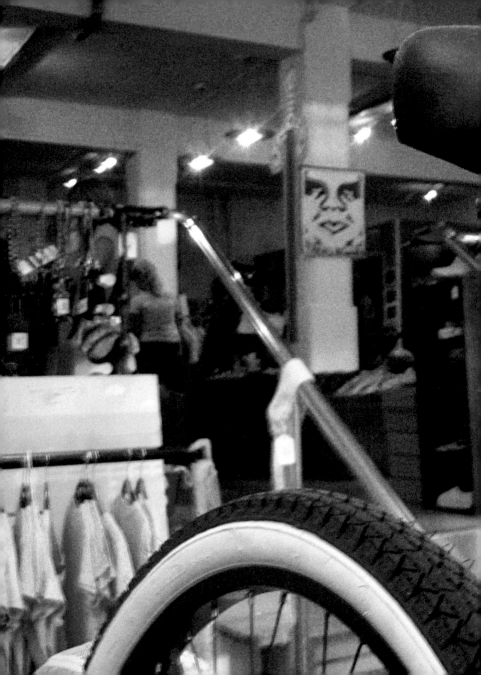

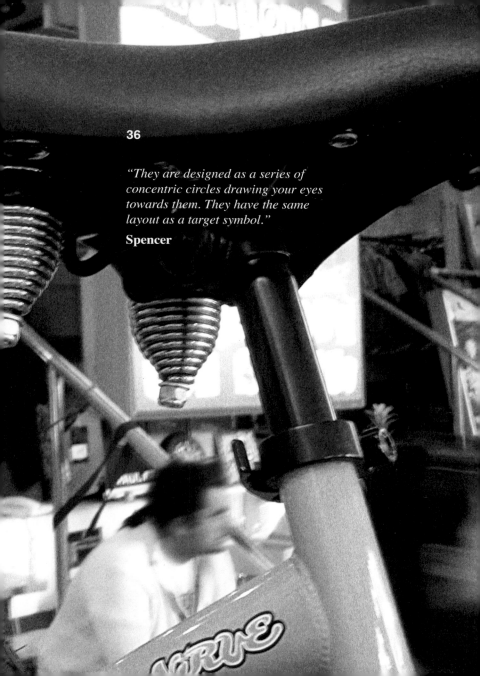

"They are designed as a series of concentric circles drawing your eyes towards them. They have the same layout as a target symbol."

Spencer

37

*"I find it ironic that the catwalks
and glossy magazines are full of
super-skinny women with small ones.
But blokes' magazines and tabloids
are full of women with large ones."*

Roger

38

"They are a beacon to our ever wandering eye. A glimpse of what is not ours."

Daniel

39

"The best ones point North. When I was a teenager, we called them tooth chippers."

Bob

40

"With objects as beautiful as that I can understand why women spend hours in front of the mirror."

Marc

41

*"I think women like being admired
as much as we like admiring them.
Over the centuries they have learnt to
use them as the most potent weapons.
No man can stand up to the challenge."*

Hemant

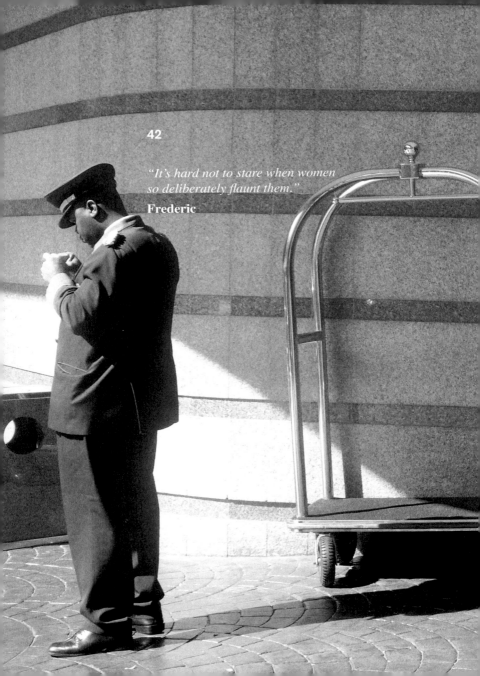

42

"It's hard not to stare when women so deliberately flaunt them."

Frederic

43

"There are villages where I am from, where the women don't cover them up. Therefore there is not the same obsession as you have in this part of the world. Covering things up can make you want them more."

Arinola

44

"With age, if things are left to nature, the inevitable happens. Like migrating birds they have little choice but to head south."

Dean

45

"Like the human face symmetry is a key factor."

Craig

46

"The best ones are real and don't need any support. Very few women have these. Most require the assistance of a brassiere to return them to their original position."

Antoine

47

"It never ceases to amaze me what a wonderful effect ice cubes have on them."

Barnaby

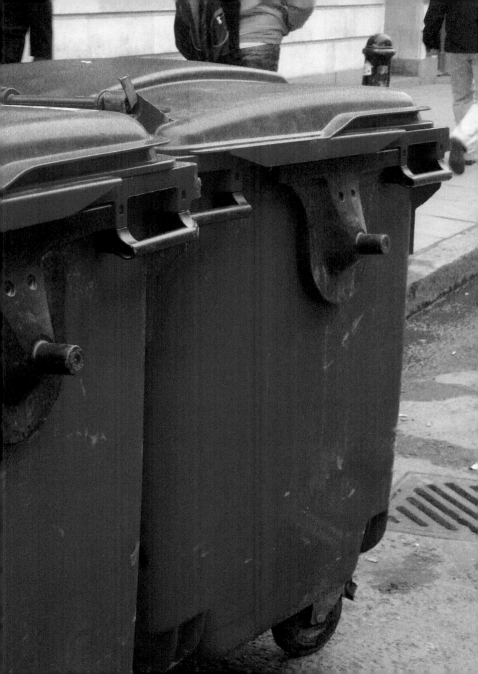

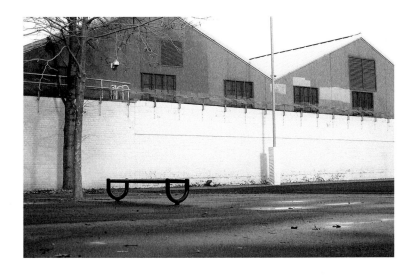

48

"Small can be perfect."
Kim

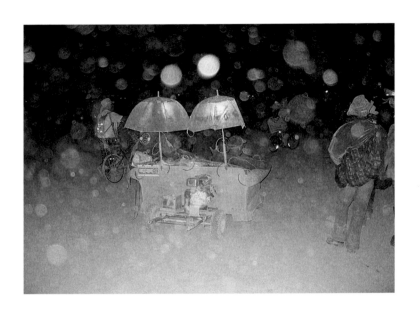

49

"They are one of the best designs ever, perfect curves, velvet touch, a built in wobble with a reactive cherry on top, and there's two, one for each hand.
Just perfect"

Garrick

50

"My sister told me it was at school that she discovered their potential as a memory aid. All the boys knew her name."

Ben

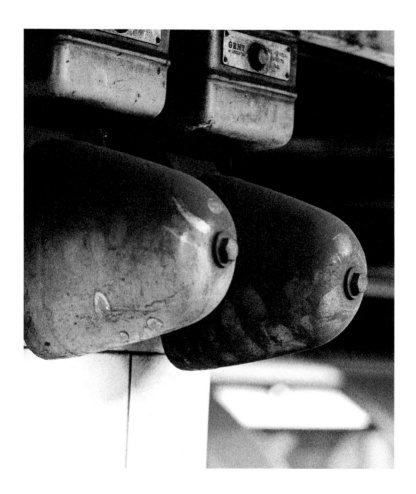

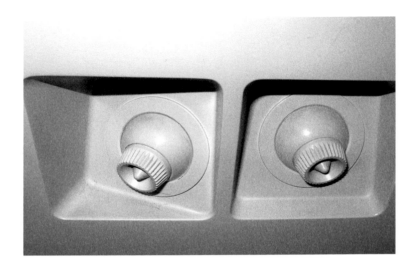

51

"They are superfluous in the sexual act. And yet we insist on playing with them."

Michael

52

"We watch countless wildlife programmes where often it is the male species that strut their stuff to attract the female. But in our case it seems to be the other way round."

Harry

53

"It's like art. There is a golden mean, the perfect balance. You know it when you see it."

Carlos

54

"The excitement of meeting and handling a new pair is thrilling. That said there are some you long to hold again but know you never will."

Hugh

55

"I'm not interested in plastic ones.
Anyone can have these, they all look
the same."

Adam

56

*"It's just a fixation to keep us away
from money and everything else,
something to keep our minds focussed.
Ninety per cent of the time men are
only thinking of women or money.
And it's much better to think of
women. Money is a terrible thing."*

Mark

57

"Just looking at them can get you into so much trouble. Every pair should come with a warning."

Boris

58

"Nowadays we hardly ever see a real pair in the media."

Eugene

59

"You can hardly blame us.
We have them forced into our
mouths the second we are born
and then respectively every time
we open our mouths to scream.
It's a Pavlovian response."

Ian

60

*"I guess I really didn't realise how
important they were until my wife
started feeding my first baby. What
used to be my daily fix suddenly
became a pint of milk for my son.
So they became quite important in
a different way, less sexual and more
about survival, living and growing."*

Rupert

Thanks to Phil, Louise and the team at Carter Wong Design for the design.

Nicole Ingram for her photography.

Guy and the two Jons for their contribution.

Gail for her support.

Jennifer for making this happen.